Such Capable Hands

A compilation of personal stories collected by
Pat Robinson Schmidt

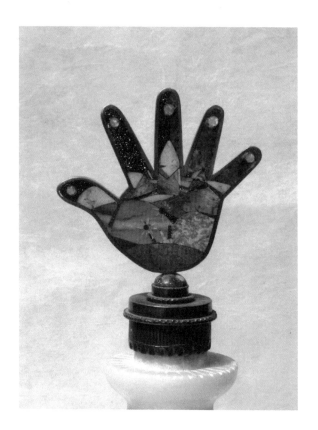

"By far the jewel had become consciousness of a vision that was shining inside me and was radiating from my heart up to my mind and continued further down to the body, to the hands."

— Sergio Figar

Published by Orange Hat Publishing 2012

ISBN 978-1-937165-17-8

Printed in the United States of America

Special thanks and acknowledgment to Kris MacDonald for
her time and talent on creating the calligraphy for each name.
Thank you!

www.orangehatpublishing.com
Milwaukee, Wisconsin

Dedications and Thanks

Thank you to my Mom, Ann Robinson, for, among many other things, the inspirational title and to my Dad, Stan, for telling me that I could be anything I wanted to be.

Thank you Larry Schmidt, my husband, for listening to the unending ramble of whatever is on my mind at the moment. You are a very patient and kind man. I love you!

Thank you lovely daughters, Emily and Annie, for growing up. You spark my love and creativity every day.

Big thanks to my two studio mates, Elizabeth Novak and Elizabeth Seifert. Your creativity and generous spirits are appreciated. Your jewelry skills and work could fill a whole book! I look forward to many years of sharing our cooperative studio environment!

Thank you Jen Herro, my deepest friend, for your unconditional love and lifelong encouragement in everything creative. You are an integral part of every day.

Most importantly, a sincere thank you to the sixteen accomplished and creative artists who trusted me when they had no reason to. I dedicate this book to all of you.

Be sure to visit suchcapablehands.com, where you will be linked to our Pinterest board, Facebook page, and Twitter.

Contents

Forward

In 1988 my mom and dad came to our house to welcome my first daughter, their first grandchild. My mom was a big help introducing me to the world of motherhood. Out of the blue she grabbed my hand, palm side up, and exclaimed, "Such capable hands!" I can see my hand right now as clearly as I saw it that day. I felt affirmed in all that I did, changing diapers, cooking and creating when possible.

Today I cannot even begin to comprehend the number of specialists working on very specific skills in various venues around the world. There are individuals everywhere who are willing to share their passion with enthusiasm and thoroughness. When I have the chance to meet with and listen to these experts, I consider it a privilege.

I am a jewelry nut—not an expert—but a lover of the preciousness, the sentimentality, history, and tactile quality of jewelry. I love to wear it, make it, and learn about it. When I was little, my grandmother shared her travel adventures and stories behind her beautiful jewelry with me and she would put a piece in my hand now and then to keep. These are wonderful memories. Now Facebook has given me the opportunity to look at beautiful jewelry made by individuals all over the world. Their work is beautiful and inspiring, and showcases skills achieved from years of learning and practice. But their stories of how and why they create are even more beautiful and inspiring.

I started making jewelry for my mom. My parents traveled a lot and she wanted really good looking rings with impact and substance. I made "traveling rings" for her, which led to more and more interest in making pieces that I didn't have or couldn't find. I learned hand engraving, taught myself some stone setting techniques, and continue to fabricate and cast pieces. The biggest reward for making and selling jewelry is hearing, "you made my favorite piece of jewelry, and I wear it every day."

Sixteen individual artists are represented in this book. They only know me through Facebook. How else could we have ever met? When I invited them to be a part of *Such Capable Hands*, it was a leap of faith and trust for them to believe that I would handle their stories with care and respect and, in turn, deliver them to you. Please note that in many stories the role of an adult in their life was instrumental in sparking their curiosity and creativity when they were quite young.

I am proud and honored to introduce you to sixteen unique, talented and passionate artists who are willing to share their personal stories with you.

ANDY COOPERMAN

"Just do it. What's the worst that could happen?"

– Andy Cooperman

M inds are like flypaper, at least mine is. All sorts of strange and unpredictable things get stuck to it. Beautiful things, unsavory things; commonplace things glimpsed in a different light. It could be a new material or maybe something so ugly and funky that it becomes beautiful. A little factoid or obscure detail can thrash around in the glue until it wriggles in and begins to burn and fester. Whatever it is, it's something that I need to somehow address or more fully understand, something that I need to pull off the sticky brain-paper and talk about. Making is my way to reconcile and respond, to pry things open, peer inside and then share my observations. In the end, it's as simple as this: some things just *have* to be made. It's the only way to scratch the itch.

My mother is the person that immediately comes to mind when I think about my early exposure to art and making. She painted canvases and a mural of tiger lilies and mushrooms (maybe a frog, too) on the long wall of our laundry room. I have her paint box with its brushes, palette knives and ancient tubes of oils somewhere in the house. She used to make dinosaurs out of modeling clay with me when I was sick and home from school and—the best— in the winter she made detailed drawings on construction paper of cocoons and insects that we cut out and put in jars (during the winter I profoundly missed bug collecting). Mom also wrote and she encouraged me to do so. But as I think about this, I realize that's only part of the story. Because it was my dad, an electrical engineer, who taught me about objects. His small shop in the basement was where I learned to hammer a nail straight, all the way in rather than pounding the bent-over steel until it disappeared deep in the wood. He had a coping saw, although I can't imagine why, since to my recollection he never coped anything. Dad told me that it was also called a "jeweler's saw." I used it to cut wood which I clamped in a green vise bolted to his shaky workbench. And we built plastic models of the Phantom fighter jet and a long Polaris submarine whose hull could

be opened to show the torpedo room and missile tubes. We built the "Visible Man" too. He had a clear plastic skin through which shown his bones and organs. We painted his liver maroon and his lungs slate blue. The colon was army green. The "Visible Horse" followed but, sadly, we never got to the "Visible Woman." I really loved building these things.

I learned the fundamental skills and processes of metalsmithing—sawing, filing, forming, forging, casting, the basics of stone setting—in a college art class called "Jewelry and Metalsmithing" taught by a Montanan named Don Johnson. His approach was loose and open. If my initial exposure to metalsmithing had been in the classroom of a tight or dogmatic instructor, I doubt that I would have continued. This was also where I was exposed to the idea that metal could be made to look like something other than metal, like wood, shell or skin. Jewelry could be more than polish and sparkle; it could be made animate and vital. On the first day of that first class I was shown images of Albert Paley's forgings, the mokume gane work of Gene and Hiroko Pijanowski and the quirky, beautiful stuff that J. Fred Woell cast.

Don had a philosophy: If you want to learn how to do something, really learn how to do something, spend time with the people who are making a living doing it. This dovetailed with my own attitude. Perfect. So when I left school I took any job that might in some way relate to metalsmithing. This was the early 80's, gold and silver prices were soaring and people were cashing in selling jewelry, watches, gold fillings and old flatware. The job that I found buying gold and silver in a mall kiosk taught me about the relative value of labor and material. It also supplied me with gems of all sorts, since the owners of the company didn't want to bother with them: gold fever. My wife Kim's engagement diamond came from that job. (I would be remiss if I didn't mention the faith and support offered by my wife Kim—from the very beginning. She may have more faith in art than I do.)

Gold prices went down and that job went away. When they shut us down, the owners of the company gave me the pennyweight scale that I still use thirty two years later. After that I made teeth in a dentist's office. Crowns and bridges are cast and finished using the same processes and equipment as in the metals studio, albeit with much more precision. I discovered new tools, honed my wax working skills and learned to cast with confidence.

But it was probably the bench jobs that had the most profound effect. I must have had three or four jobs at trade shops or jewelry stores, working along seasoned and often salty jewelers. They had an amazing depth of knowledge, little tricks and tweaks that I would have never learned in school. Every day I sized rings, carved waxes, made rubber molds, and set stones. For the most part the old pros were generous and willing to share their experience. But they didn't understand the type of work that I wanted to do. Jewelry making was a job to them and jewelry was a specific thing. In one jewelry store, we made nearly everything that our customers ordered. I had already been doing a small amount of custom work on my own, but that job made me much, much better at it. After a while I grew weary of the disdain I encountered for conceptual or edgy jewelry and I went out on my own.

2

I should add that during all these stretches of daytime employment I made my own work at night and on weekends, applying what I had learned at work. And that's what it took for me to get technically good enough to take the ideas in my head and put them in my hand.

I am a maker. Making for me isn't limited to jewelry, sculpture or objects. It includes writing and, in a way, teaching. I'm not sure that I would be willing to give any of those things up and, while I don't always enjoy the making, I always enjoy having made. There is nothing like having something sitting in front of you— an essay, a brooch, a picnic table—that wasn't there before. Nothing else really compares.

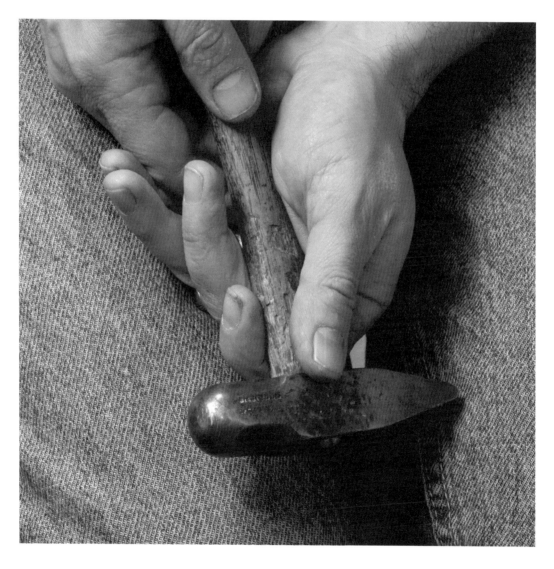

Website:

andycooperman.com

ANDREAS ROTH

Idar-Oberstein, Germany

"When nature begins to reveal her open secret to a man, he feels an irresistible longing for her worthiest interpreter, Art."

– Johann Wolfgang Von Goethe

I am a master gemstone engraver. I live and work in Idar-Oberstein, a city in the southwestern part of Germany. Idar-Oberstein is famous for gemstone engravings and has brought forward many renowned master gemstone engravers.

Before I could obtain master craftsman status I had to go through several stages of training. At the beginning of my career in 1989 I completed a three-and-a-half-year apprenticeship for gemstone carving and engraving in the studio of Master Gemstone Engraver, Hans-Dieter Roth (my father). Later on I attended classes in the goldsmith craft. Throughout 1999, I enrolled in special courses to obtain a master craftsman diploma in gemstone carving and engraving. As a master gemstone engraver I specialize in all facets of carving and engraving gemstone cameos and sculptures, cameo portraits, large cameos, and gemstone objects. The art of precious and semiprecious stone carving (glyptic arts) dates back to antiquity and reached full bloom in the fifth and fourth centuries B.C., in the so-called "Golden Age" of the Greek classical art.

For my objects of glyptic art, I mainly use multi-layered agate stones. My tools are drills and rotating wheels impregnated with diamond powder. When starting to hand-carve a gemstone I first sketch a design, portrait, or scene on the surface of the stone with a diamond stylus. I hold the stone in my hands and move it against a revolving cutter in order to gradually cut the superfluous material away from the design. While the design is drawn using the largest drill points, finer points and more delicate tools, such as diamond points, have to be used to work out the details and refine the design. The finishing touches are done with diamond points.

As a young boy I spent much time in my father's studio and admired his skills and finished pieces of art. My father set an example for me, and by my early years I

4

was inspired to emulate it.

I was fascinated by my father's works of art, and because I was talented in drawing, modeling, painting, etc. I had the strong desire to create something with my own hands, to realize my own ideas and to become an artist. The art of gemstone engraving is my profession, which I am proud of and like very much.

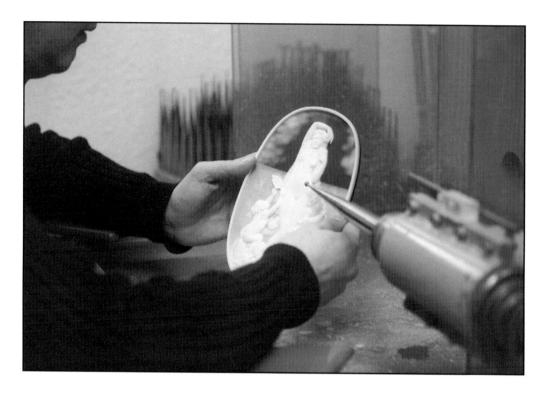

Website:

roth-cameo.com

KHATUNA ROINISHVILI Tbilisi, Georgia

"I just want people to show once more how endlessly beautiful the world is."

– Khatuna Roinishvili

I was born in the ancient and picturesque city of Tbilisi, the Georgian capital. My homeland is a beautiful country of legends where incredibly beautiful women and brave men live. Georgia is a cradle of ancient culture and art. Homer tells the story of my country when the Argonauts accompanied Jason to Colchis, an ancient Georgian kingdom, in an attempt to find the Golden Fleece. My people, the Georgians, have a rich cultural legacy; they are descendants of the sun.

Cloisonné enamel is famous in ancient Georgian art from the 6th and 7th centuries. The skill demands fine craftsmanship and sophistication. The technology of working with colorful glass, pure gold, and silver requires neat and precise work. Pure gold (24kt. 999) and silver are necessary enamels for the manufacturing of precious things.

The main thing that sparked me to create was the love I have for my country, Georgia, and its traditions. In my childhood, I had a dream to be a good painter but for some reason I could not reach my aim and this was very painful for me. But then with my husband's help I continued creating with cloisonné enamel. My daughter is a beginner painter and we spark each other to create and to work.

I try to combine old and up to date techniques. I'm a self-taught painter. I had several technical lessons in cloisonné enamel, but only very technical lessons. I soon discovered my own manner of working with enamel, and developed my own style. I had a very good teacher who taught me many things, too. I acquired my specific skills with my constant searching to have my own style and colors. I try to keep each item in its own style, personality, character and boundary. This is how I set the course of my creative process— the tenderness, elegance and diversity of colors.

6

The world has a lot to offer humanity and we, in turn, make art that reaches celestial heights. I try to use these small grains of grace to do this.

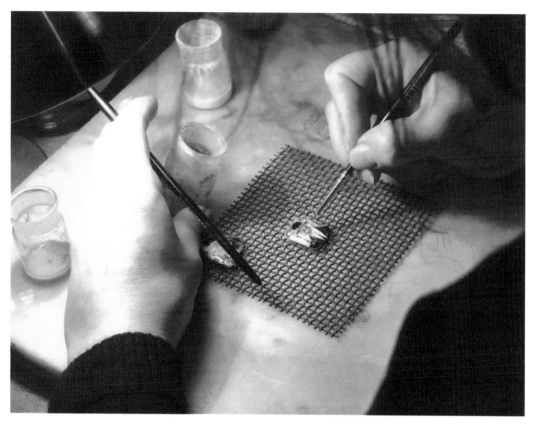

Learn more about Khatuna and her work by visiting
her Facebook page, KHATUNA-ROINISHVILI.

CARLOS GODOY

Pinheiros, São Paulo, Brazil

I am the son of a talented pianist father, and a mother who is a skilled painter and draftswoman. Both are art lovers. I have always had contact with the wonders of art, and from an early age had a passion for it.

My first creative steps began at a very early age with drawing, followed by painting, sculpture and printmaking. I was always supported and monitored very closely by my parents and grandparents. They helped me develop my abilities, feelings, ideas and ideals and they helped me trace my path.

I clearly remember the first award I received, and my first exhibitions as a schoolboy, inexperienced but eager to express myself. I was learning to evolve and contribute effectively to the development of art and everything that surrounds it.

At age twenty two, my first solo exhibition was unforgettable. I had my first interview. I remember the overwhelming emotion of my grandparents, as evidenced by the tears dripping from their beautiful eyes and smiles ripped directly from their generous souls. I remember the happiness and pride of my parents, who could barely speak, and the close embrace of brothers, friends, and employees along with the complimentary comments from the gallery.

But there was something else that fascinated me. I thought about the jewelry worn by my mother, her beauty and her brightness. I was fascinated by the colors of gems and pearls, the exquisite work and delicate perfection, detail, precision. I loved to "play" with all those beautiful things, of course it always was under the eyes of the owner.

There was a small book at home called *Gems of the World* by Walter Schumann,

one of my favorite books ever. I remember spending hours and hours looking and reading about these marvels of nature, imagining that one day I would have some. It was certainly my first contact with the more intense world of jewelry.

Time passed and my interest and understanding of this marvelous universe only grew. With my background in sculpture and painting already well developed, I began to make ornaments made of epoxy resin, glued brass, copper and aluminum fixtures and hand painted with acrylic paint. These materials were easily accessible and somewhat inexpensive. My growing interest, passion and desire to improve myself technically and my desire to work with precious metals and gems was uncontrollable.

As I have always been self-taught in everything I did, I was reluctant to look for courses. Consequently, I could not grow and go where I needed. Access to materials and information was very difficult, if not impossible, and I knew nothing. At the time there wasn't any kind of publication on the subject, much less available producers of materials, sheets, wire, solder, etc. All knowledge was concentrated in the few existing schools and in some artists and industry professionals, all of which were far away from me.

In 1989 I passed in front of a school announcing an upcoming course on jewelry. I could not restrain myself. I stopped and I signed up. From that impulse moment, I would be permanently and forever captivated by metal and gems.

I remember vividly the first day of school. Upon entering the classroom I came across a book titled: *Mokume-Gane.* It was a text written by hand on sheets that were very messy, because of so much handling. There was very little information but it described the soldering technique step-by-step. From that moment on, I never stopped working with the centuries-old Japanese technique. I remember the enormous work and the enormous frustrations of the first studies, the first plates, the first results of the first pieces. It was like magic, and only increased the satisfaction and the desire to do more and more. I kept working, studying and developing the technique by welding, obtaining better and better results.

In 1993 I had access to the book *Jewelry: Concepts and Technology* by Oppi Untracht, from which my artistic horizons widened. Then came the texts of Pijanowsky, James Binnion, Steve Midgett and Ian Fergusson, and the universe of mokume gane took on new dimensions and immeasurable possibilities.

At this point the obsession with color, the search for new textures and patterns, new combinations and new contrasts coupled with issues of form and their applications, became a constant — probably a remnant of my experience with painting and sculpture — and is the line master of my work in jewelry. I am moved by this passion, this interest for these issues and their relationships. This is my poetry. My art.

I am proud and pleased to be one of the pioneers of the technique of mokume

gane in my country, Brazil, and to be part of the process of revitalization and dissemination of this wonder in the world. My work is recognized and praised and has received important awards.

My proudest accomplishment is to be passing on the knowledge that I've acquired over twenty years of hard study, research, work and passion to as many people as possible through the courses I teach. I can see that mokume gane is becoming more recognized and admired by a growing number of people.

Website:

mok.com.br/

CHRIS NELSON <u>Goldsmith of "Urban-Armour"</u>

Pagosa Springs, Colorado

"All it takes is all you got."

– Chris Nelson

I have always enjoyed working with my hands. Most of my life I have lived on the seashore or in the mountains, generally more focused on the minute details of nature that surrounds me. The permanence of metals and how they become molten with fire has always been intriguing. When someone says you can't do a particular task or technique, if I am curious enough, I know that it must be attempted and I will either fail or master it in my repeated efforts. It is in my DNA. My work and my life are about bringing all of these elements together into something that makes sense and has inherent beauty, and requires little verbal description to be appreciated.

My dad wanted to become a commercial artist and was in art school in LA after he got out of the army but the need to support a family forced him to quit his vision. He found his art in growing things, and was always experimenting with grafting trees and working with exotics and bonsai. In later years he began some basic blacksmithing, but never truly developed his skills. My mom liked to sew and knit.

As a five year old, I made a pattern and cut out and sewed a cloth bag for my marbles with my mom's supervision. When I was seven, my dad and I built a little, seven foot long flat-bottomed wood boat called "Punky." My parents had a little kiln when I was maybe eight, and our family would do some copper enamel together. I remember forging out a nickel on my dad's new concrete garage floor and leaving dents when I was ten, and I was severely reprimanded. I remember putting pennies on the railroad tracks when I was thirteen, and I was amazed how they got squished by the train.

At thirteen, I took a metal shop class in school and learned to sand cast aluminum. I made my skin diving weights by casting lead that was melted on my mom's stove, and poured into aluminum molds that had been sand cast.

11

I wanted a minibike when I was fourteen and asked my dad to help me but he said, "You will not learn if I do it for you." So I ordered a plan, bought the pipe, made all the bends and ground them to fit, and had a welder weld them up for me. It came out better than the plan without much supervision. And it was really fast, but the brakes didn't work so well.

At age fourteen my science project was to demonstrate Pasqual's laws of hydraulics. I fused together various glass tubes of different diameters with a torch to house the colored water and show how hydraulics worked.

I began building wood fences at fifteen years of age to make some money in the summers, and found that I liked to build stuff out of wood. I really liked using the power saw and hand nailing all the nails.

At age eighteen I worked for the summer in an aircraft factory deburring metal parts. I was promoted after a month to do "scribe and drill" on the parts. The following summer I worked again in the aircraft factory, and was operating a 320-ton Warco hydraulic press forming huge "skins" for aircraft.

At age nineteen a friend was taking a jewelry class at San Diego State and showed me how to make a potter's clay mold to cast molten sterling silver. I got an after-school job working as a dental technician in a crown and bridge lab and was doing simple waxes and all the casting for the lab. This led into a couple of years of being a 'hippie jeweler.' I spent time casting organic stuff and selling pieces to head shops in California. I graduated from college and continued to make jewelry for a little over a year while also working for a taxidermist making mannequins.

Then, with a new family, I became a journeyman carpenter and production piecework house framer in California for some years, and ultimately became a building contractor, doing many phases of the construction for fifteen years. I did most of my own design and drafting. I then worked another fifteen years as a professional estimator on very large commercial building insurance losses, and did fast-track project management on catastrophes where my computer skills were greatly enhanced.

I was encouraged by my dad to do things with my hands, to do it right the first time, and to always challenge my skills and learn new ones. He taught me to use tools and respect them. Over the years I learned much by watching skilled professionals and asking a lot of questions. Sometimes I would just go for it, but my drive to learn and excel would not allow me to quit, so I developed many hand skills and knowledge bases over several decades. I am not sure where this drive actually came from but I loved working with my hands and using my brain to figure things out. And I loved tools and mechanical things. It's the same thing with my metals today, always exploring and never satisfied, and always looking for the next challenge.

I know my dad would be amazed if he saw where my life and work has gone.

I have never apprenticed with anyone in metals, but have had several mentors. I already had a skill base with a lot of tools, hammers, torches and layouts from past life experience. I began working with jewelry in 2001 after not making any jewelry for almost three decades. I retired from my professional career in 2001 while living in the Caribbean, and began working on projects from Alan Revere's book *Professional Metalsmithing*. A friend that lived there and did repair was showing me a few things and recommending tools and asked what I would like to learn from her. I said, "Channel set diamonds." I started making my own mokume gane with silver and copper using hard solder rather than fusing. I loved working with the jeweler's saw and files and doing really complicated pieces, in combination with the skills I had.

I realized that metal was my passion and committed to moving back to the mountains of San Diego at my dad's house to set up my studio. My intention was to take the Jewelry Intensive at Revere Academy, but my dad was really sick and I decided to put off the class. He died thirty days after I returned from St. Thomas.

I heard about Marne Ryan, and that she was teaching a master's symposium at Revere, so I signed up for classes with Marne, Tim McCreight, and Jean Stark in April, 2002. The class lasted for twenty one days straight. I was totally hooked. I learned so much about fusing and granulation and about fusing silver to silver, gold to silver and gold to gold. The torch and fabrication was so exciting and challenging, and is still my passion.

I was intimidated by all the younger people in the class who had studied at Revere and were so well trained. For so much of my life I had learned by watching, really observing, all the little nuances it takes to master any skill, and asking a lot of questions. Practicing the new techniques full time, along with constructive critique from Marne, my skills advanced fairly quickly. Over the next six years I knew where my gaps were and who I wanted to learn from, and took specific workshops from Doug Zaruba, Carol Webb, Lee Marshall at Bonny Doon Engineering, Inc., Harold O'Connor, Marilynn Nicholson, Alan Revere, Naohiro Yamada, and ultimately Michael Zobel.

Each of these metal artists impacted my work in specific ways, and several of them I considered mentors, although there were no formal mentorships. I would present new pieces to each of them and ask for critiques.

The first piece I brought into public was a neckpiece, which I called "Remergence2012," and it was brought to the Snag "Clasp" conference in September 2007. I had not shown any work or tried to sell any work prior to that. The 12 karat Egyptian electrum and 20 karat golds were alloyed in-studio and totally hand forged and ninety percent of the piece was fused. That piece and two other volumetric archer rings of fused 12 karat and 20 karat golds were submitted to the AGTA Spectrum awards in December 2007. I began doing juried art festivals in May 2008.

The skills I have learned have come with hundreds of hours of practice to perfect the skills and gain ultimate confidence in my hands and tools and the torch

fusings. I create mostly organic work, although I can work to very close tolerances and create pristine work if I choose. I alloy and mill all the gold I use and work with six specific high karat alloys, plus the 12 karat Egyptian electrum gold.

I began to work in iron in April 2008 after studying Zougan technique at Revere Academy with Naohiro Yamada. It was a slow and tedious process, but I moved into it slowly, still working mostly in fused golds and some silver. In 2009 I received first place in All 3D work at a show in Salida, Colorado, where Harold O'Connor was a judge. At the show, a Kansas farmer thought I was a rock star and ultimately bought seven pieces of my earlier iron/gold pendants.

I continued to work more with iron and gold, and in May 2010 the brand "Urban-Armour" was launched. The learning curve of fusing iron to gold has been huge, as there is little information about the use of iron and gold fusings. An understanding of technical goldsmithing and alloying jump-started the hand fusings of gold to iron at close to 2000 degrees. The college chemistry that I had not acknowledged as understanding or had ever used has entered into the work/play with iron. Plus hundreds of hours experimenting and recording results as to what textures create what patterns with specific alloys.

Each piece brings more clarity and sophistication of design. The challenge is to create a painterly effect with a mix of the various alloys, work with ninety-five percent "green" post-consumer recycled metals, attempt to work as closely as possible to green in studio practice, and create pieces in iron and gold that are as well fabricated as those of my pieces that are solely gold.

I didn't really feel like I was creating art until late 2008. I was doing quality technical pieces, but really had no training or basis in art, per se. I felt like I was in a slump with metals and the designs were becoming increasingly trite, so I devoted six months to working in hand built and wheel in clay. Also I took a reductive ink print making class. The instructor was a retired architect and an amazing artist in printmaking and clay. He incorporated a lot of principles of art of which I had no knowledge or understanding. After this six month sabbatical from metal, it seemed that my metal work began to have a bit more of an artistic flavor.

I have always been intrigued by the micro and macro of nature, and in my wanderings from earliest childhood have always picked up small bits of nature or mentally recorded colors, textures and form. Much of this influences my work, and I feel the need to express some of these perceptions, often in subtle ways. It is more intuitive than forced. I love the tools, the metals, and the meditative flow that creating brings to me. I like to make wearable art and art has become my life and is what fires my soul.

The drive today is the knowing that I have not done my best piece yet, and it could be the next one...or not. But there are so many visions and inspirations yet to explore.

Websites:

chrisnelsongold.com

urban-armour.com

CLAUDIO PINO

Montreal, Quebec

"Creativity is that marvelous capacity to grasp mutually distinct realities and draw a spark from their juxtaposition."

– Max Ernst

The power of rings. What makes a ring powerful? Is it the interplay of shifting light, shadow and depth created by the unique combination of metallic, matched colors, or is it the unmistakable power of the vintage surface that recalls memories and projects? I have always been inspired by the ancient art of jewelry making, especially the history of rings.

My artistic interests have been drawn to the personal relationship people have with the jewelry they wear. Sometimes I add meticulous mechanisms to give the stone set the freedom to follow the owner's movements, reflecting the wearer in many small, intricate ways. Each of my designs represents a different thematic system—a mirror of multiple metaphors. Whether exploring systems in motion, metamorphosis of insects, or the pace of urban life, my passion awakens first in the transformation of the raw material.

Since 1999, I have been dedicated exclusively to jewelry design, particularly one-of-a-kind jewelry. The combination of colors is one of my sources of inspiration. In my designs, I juxtapose cold silver to the warm gold, calm green emeralds to vivid red rubies to the hue of the charm and freshness of whitewater pearls. Each design portrays a slice of life, a perspective of the rhythm and poetry of the world in which we all live. From conception to completion, I am searching for originality, innovation and integrity of expression and elegance. I explore various forms of expression to bear witness to the historical grandeur of jewelry making and at the same time animate the design with contemporary tones. During the creative process, I never forget that someone will be wearing the ring. Therefore, rings first need to be very comfortable and belong to the hand. My rings come alive only when they find their owners.

During my childhood, I could spend hours drawing and painting. I always

have been fascinated by design and architecture; colors and shapes. I remember standing for hours looking at my father who, after his day of hard work as a plumber, was making wooden ship models. He was carving the wood patiently, piece by piece. Each miniscule part was meticulously painted by hand with so many details. My father's hobby was precisely reproducing models of ships from scratch. I remember my amazement as I watched each ship slowly take form over months of painstaking work. When I told my father I wanted to study art, he said to do anything I wanted, as long as I did my best and with passion. Since that day, I have wanted to transform raw materials into precious objects.

To me, making jewelry involves a search for innovation that forces me to confront new challenges. In the beginning of my career, I experimented with different techniques, such as wiring methods, lost wax casting, and piece by piece construction. Currently, I try to create my rings by focusing mainly on the emotions or feelings that the design conveys to its owner rather than production techniques. I devote all of my time and energy to the creative process.

The development of my techniques and skills resulted from many years of hard work ethic, discipline and perseverance as I worked alone in my shop. Since obtaining the Professional Jewellers' Diploma from the MEQ Jewellery School in St-Henri, Montreal, in 1995, I have been working full time on my jewelry bench. Over the years, I have also studied at the École de Joaillerie de Montréal, where I earned a certificate in lapidary. From 2001 to 2002, I continued my research in gemology and mineralogy in Albuquerque, New Mexico. In addition, I received an advanced training certificate in faceted gem cutting through the CMAQ. During the course of my career, I had the opportunity to participate in several exhibitions, biennales, trade shows, and a few internships in North America, Europe, and Asia. These exhibitions have enriched my artistic network, stimulated exchanges within various communities and helped me develop my expertise.

In 2008, I was awarded with a grant in research and creation from the Conseil des arts et des lettres du Québec in order to study the origin of jewelry within the First Nations of North America and create a collection melding traditional craftsmanship in jewelry with modern aesthetics and techniques. This research allowed me to deepen my artistic skills by studying these ancestral techniques with artists from the Naskapi and Innu-Montagnais communities in Quebec as well as the Navajo Nation in Arizona. This project had a huge impact on my creative process.

Furthermore, to deepen my knowledge on the history of engagement rings, I went to the Egyptian Museum in Cairo, which contains the largest collection of ancient Egyptian Jewelry in the world. This collection includes one of the first engagement rings, which was owned by Queen Aah-Hotep, the mother of Ahmose. Seeing the Pharaohs' jewelry and meeting with well-known specialists allowed me to better understand the ancestral techniques and customs as well as to learn more about the symbolic importance and origin of the engagement ring. This research and creation project had a real impact on my artistic career, and it is from this rich experience that I designed the Vena Amoris Collection. This project was made

possible in 2009 thanks to the Conseil des arts et des lettres du Quebec.

In 2011, I pursed a master's degree in the study of platinum at Holts Academy Jewellery in London, England. In addition, I received intensive individual training from the world-renowned expert on platinum, Mr. Jurgen J. Maerz, director of Jewelry Industry Consulting, LLC and former director of Technical Education for Platinum Guild International USA. This unique training allowed me to feed my need to conduct artistic research and enriched my technical knowledge. In 2013 I will present an exclusive collection of sculptural rings made with the rare and stunning metal, platinum. With this collection, I intend to incorporate the exquisite properties and poetry evoked by this luxurious and sensual metal in my designs. This project is made possible through the support of the Arts Council of Canada.

Making art is a way to express emotions, ideas, and narratives, and share them with others. It is also a way to stimulate our senses and evoke synesthetic-like experiences. I have always wanted to create precious objects and wearable embellishments. The transformation of raw materials into something usable is limited only by our imaginations. As a kid, I would always ask to look inside jewelry boxes; I was mesmerized by the vivid colors of the stones and the shining gold, dreaming of one day becoming a famous jewelry-designer who could create a magic ring like the ones in the dragon's tales. Since childhood I have wanted to live out my passion for jewelry.

Each time I start a new design, I imagine the day it will find its owner. This special relationship helps incubate the concept. My process then progresses as I explore different emotions and themes, which is both challenging and exciting. I seek a combination of physical attributes, sculptural portability and making an extension of the body. The jewelry must feel extremely natural, assuring comfort to the wearer yet always different to the eyes of the observer. For me, this allows my creativity to flourish continuously.

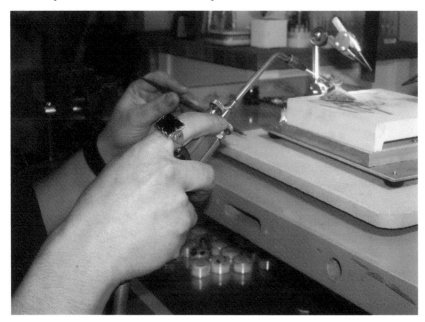

Website:

pinodesign.net

DAVID HUANG

Sand Lake, Michigan

"You must be the change you wish to see in the world."

– Gandhi

Treasure! This is something that I think about often. I hear people referring to my vessels as "treasures" and realize it is what I've been creating. Is this some subtle influence from all those sci-fi/fantasy novels I read as a kid, and to be honest, still read from time to time? I couldn't grow up to be some heroic person out questing, slaying monsters, and discovering fabulous treasures. Is this how I make do?

Perhaps, I really don't know. I do greatly enjoy questing; only I call it camping, exploring new landscapes with all their wild, complex beauty. In the absence of discovering those great hoards of treasure I guess I just had to make it myself. Slaying monsters? Well, who really wants to do that? I suppose a fantasy novel would lack pizzazz without the monsters, but personally I'd prefer going straight from questing to the treasure.

But what is it that I treasure? Clearly metal is one thing. It's such a fascinating substance. I love the way it moves under a hammer, the colors it is or will become, the way its lustrous shine dances with light. The copper, silver, and gold I use the most all occur in the natural state. I like the romance of thinking I could be out exploring some forest, find some nuggets of metal, perhaps along the edge of a stream, and be able to work this into new forms.

Treasure is generally considered only for its material nature, but I think there are other causes for allure. Beauty is one of them. I seek to create in my pieces not just beauty, but timeless beauty, like that of a natural landscape. I think of beauty as a connection; two or more things finding commonalities or understanding of the other. The longer the sensing of beauty endures and the more universal it is in its appeal, the deeper the connection is to us.

19

I also treasure the soul of a thing, spiritual matters. This facilitates the living of our material existence and spans beyond, perhaps even to timelessness. I find it intriguing that before gold was seen as money, it was the material of the gods. Why does it have this long association with spirituality? I don't know but the radiance it possesses on the interior of a vessel expresses this treasure of existence well.

It's hard for me to say what influence immediate family and friends had on my creative drive. Growing up none of my family or friends were artists. I don't believe I was emulating anyone. In fact, it is sort of a characteristic of who I was/am that I go my own route with minimal regard for what others are doing. Let's just say the term "unique" was first being applied to me while I was fairly young.

I suspect there was some influence from my father in that he was an electrical engineer. After work and on weekends he would often be down in his basement shop designing and building various projects, sometimes for side income, sometimes just for fun. So from my earliest days I grew up thinking it was normal to make things. While he wasn't artistic he was a maker of sorts. I suspect this influenced the "maker" part of me. It was always normal to think I could at least try to make or fix something myself.

It was my sixth grade art teacher, Belinda Kotulak, who really got me focused on art. This is the time I decided I wanted to be an artist for a career. I think it was mainly her enthusiasm for what I was doing that got me to pursue it more, working ever harder. Prior to that point I seemed to be just average or slightly above average at everything. Having someone think I was extraordinary at something felt good. It started to give me some self-confidence. Looking back, I don't know if I really was any good at the beginning or if she was just skilled as an educator to find what it took to pull the best out of me. Regardless, as I focused more and worked harder I got better, and thus became driven to keep trying to get better after seeing it was possible.

While admittedly my family was a bit nervous with my career choice they never discouraged me. My father had always said that my sister and I should try to find a career we really enjoy so that going to work would be more like going to play all day. Again, this is what he modeled with his life.

Metalsmithing in general is a very technique intensive field. It seems like there are always more metals techniques I could learn and try to master. There are four main techniques in my work, raising, chasing, patination, and leafing. For the most part I taught myself in all these. That is not to disregard the various wonderful instructors I've had who first introduced me to these and taught me many more techniques.

I probably have the most formal training with the raising technique. One semester in college at Grand Valley State University my instructor, Beverly Seley, gave us the project of creating an angle raised vessel. This is a technique of transforming a flat sheet of metal into a volumetric bowl/vase form completely

through hammering, raising up and compressing in the sides. I learned the basics of the process in that class on that one vessel. Since then, over the course of many years and hundreds of vessels, I've discovered tricks and approaches to raising that differ from what I was first taught. In some cases I actually break the "rules" I was first shown. So I developed my current raising technique myself from the base of knowledge learned from Beverly Seley.

With the technique of chasing I had even less formal training. This is often also known as chasing and repousse. As I understand it this really means to work from the front (chasing) and the back (repousse). It's a technique used to hammer decoration, imagery, and design into sheet metal. I was in high school at the time taking jewelry classes along with all the other art classes I could get. A student who had graduated had come back one afternoon for a visit. She was actually taking classes with Beverly Seley at Grand Valley State University where I would later end up going myself. They were doing a chasing project there at the college and the student coming back to visit the high school took about fifteen minutes to share with me the most rudimentary basics of how to put a piece of metal into a pitch bowl, hammer on it with dapping punches to give it some form, and remove it from the pitch. I started in and found I really enjoyed this technique. My high school jewelry teacher, Nona Bushman, really liked what I was doing and provided plenty of encouragement to continue. This may not mean much to those unfamiliar with the technique, but it was actually a couple years before I even realized there were such things as chasing tools. I had been doing all my work with dapping punches! This is kind of like trying to insert a screw with a hammer. It can work, but there are much better tools to do the job! Once I discovered chasing tools and started making my own I was able to develop this technique much further.

I also learned the basics of patination at Grand Valley State University. I forget if it was from Beverly Seley, my metalsmithing instructor, or Elona VanGent, my sculpture instructor. Probably a bit from both. However, the ranges of patinas I use today in my work are things I developed myself through the years by trial and error building off that base of knowledge.

The gold leafing I do is the simplest technique of them all for me. Basically I read the back of the jar of sizing used to apply the leaf and learned what did and didn't work as I went.

As my full-time job I could say that the main purpose for making art is to pay the bills, but I could have covered these financial obligations much easier with another career. So why did I choose to be an artist? As an extremely introverted and shy sixth grader, deciding I wanted to be an artist for a living was influenced by the thought that I could hide away, make art, and not have to deal with people. What a farce that turned out to be! My life now involves interacting with tons of people on a regular basis. So then, why did I instead remake myself, learning to enjoy interacting with people in order to be an artist? I'm really not sure I know why. Making art just seems to be an essential part of who I am and has been most of my life. It's a process that presents a constant stream of new challenges and

opportunities before me with each piece I make. In this way I don't get bored. Art makes me see the world and focus my attention. As my attention gets focused my perception increases. There is something exciting about delving so deeply into levels of perception that observations and understandings begin to transcend words.

I make art because I'm fascinated by the transformational process materials can make. There is a magic to watching a piece of flat metal become something so dimensional, tactile, and radiant. Through these transformed materials of my artwork, I then hope to transform and influence those who encounter it. I am seeking to propagate and elevate awareness of some of the things I value; the natural, sensual world, skilled labor, timeless beauty, and the inner spirit made visible. In this way I hope to have some tiny, tiny part in making this a better world for all. I think this is my main purpose for making art.

I may seek to change others through my art, influence their thoughts and values. To do this though, I must first make those changes myself so that I can better understand them and express them through my art.

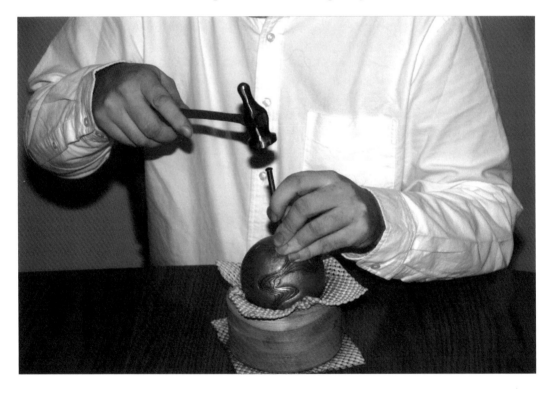

Website:

davidhuang.org

DELLANA

"The only thing that interferes with my learning is my education."

– Albert Einstein

I have always been compelled to create. As a child I painted in oils, played classical organ for nine years, sewed my own clothes, wove my own fabric, drew, painted and embroidered. While I took the required art courses in school and college, I always felt stifled in my creativity in what I was told and shown were the rules during those years.

I have been interested in knives since childhood. One of my first knife memories is of a miniature pearl-handled dagger that I kept under my pillow to fend off the monsters under my bed.

It wasn't until I enrolled in a jewelry/metals program at Skidmore College in Saratoga Springs, New York, that I truly found myself as an artist. The moment I put my hands on the metal, I knew that this was what I was meant to do. The sculptural quality of art-jewelry making and the direct manipulation of the metal mixed with the wonderful color and texture of various gemstones spoke to my artistic soul. While I love the high karat golds and other precious metals as well as the gemstones, I had no idea there was something missing until I discovered Damascus steel!

My soul is very happy working directly in metal. I tried casting once and hated working in wax. It cheated me of a very necessary part of the way I communicate artistically. I feel that this is why I so enjoy the process of forging the Damascus steel I make and use in my knives. I love the attention to detail that I must maintain to create the intricate and interrelated pieces of my knives. There is something very good for my soul in the act of hand sanding something that someone else would do on a grinder. That is part of how I speak as an artist. There is something magical that is imparted from within me during the lengthy process of bringing something from a simple thought into a tangible creation.

My personal, visual, artistic vocabulary is of beauty. I truly love creating something that is beautiful, with all parts flowing together as one. Doing this within the confines of the mechanisms of a folding knife or the dimensions of a dagger gives me great pleasure. To know that another human can enjoy not only the look but also the feel and weight and movement of what I create is very satisfying to me.

I am not at all sure that I know what the definition of art is. What I do know is that my knives communicate with people. The look of wonder and curiosity on someone's face who has never thought of a knife as a creative, artistic object before tells me that I am communicating on a very deep, personal level with many people. To me this is what art does.

My mother is an artist. She was a successful graphic artist for as long as I can remember. She encouraged me and my sister to create. One of my earliest memories is of her setting up a finger painting station for my sister and I on the kitchen counter and us happily making messes while watching the snow come down out the kitchen window. Mom always had us make our Christmas and birthday cards and invitations. I remember the thrill of being set at her beautiful wooden drafting table with access to her pencils, pens and colors to make invitations to my birthday party.

I learned how to mix flour and water to make glue at a young age. She showed me how to embroider and I loved it. She paid for sewing lessons when I was older. I was taking oil painting lessons in elementary school. She taught me how to "see" things out in nature that most just walked by.

Both my Mom and Dad always told us that we could be anything we wanted, and we were always encouraged to do so. I was very fortunate to have that in my life. Even now my Mom is a Photoshop expert creating, editing and publishing books. She had a computer and was fascinated with what you could do artistically before anyone else I knew. She's my biggest fan!!!

I started my metalsmith journey by taking a summer course at Skidmore College taught by Sharon Church. I was hooked. I knew this was what I was meant to do. I immediately signed up for the next semester taught by the amazing Earl Pardon. He taught me how to bring my creativity out as well as many techniques. After two years of studying with him, I moved to Hawaii. There, I found an amazing older jeweler named Merle Boyer who taught me about stonesetting and engraving. There was a fabulous craft community on the island of Oahu called Hawaii Craftsmen. I was very active with this group. From there I moved to Bremerton, Washington, where I again found an older jeweler who mentored me in lapidary work.

I then returned to the Saratoga Springs, New York, area near Skidmore College. They had a strong metals program at that time. Earl Pardon was still a professor and I was able to attend special workshops as well as work as the Technical Assistant for the Summer Six art program where I learned from such greats as Jamie Bennett (enameling), Pat Flynn and others. (The time frame here is up until the late '80's.)

In 1993 I met James A. Schmidt— Master Bladesmith and art knife maker extraordinaire. I was fascinated by knives and had never seen the art he was making. He also forged his own Damascus steel. He was kind enough to take me under his wing and taught me how to forge Damascus and make the mechanisms for folding knives. Having a strong metals foundation and a strong design aesthetic already was a huge plus.

I was taught a great deal by others, although not any official apprenticeships. I have also taught myself many techniques — like granulation —just because I was curious and wanted to know how and had no other way to learn than to pick up books (long before the internet) and do the research and then practice it. Now that there is the internet, it is far easier to find almost any information one wants.

I love magic. The act of creating is the essence of magic to me.

My soul finds it essential to create things.

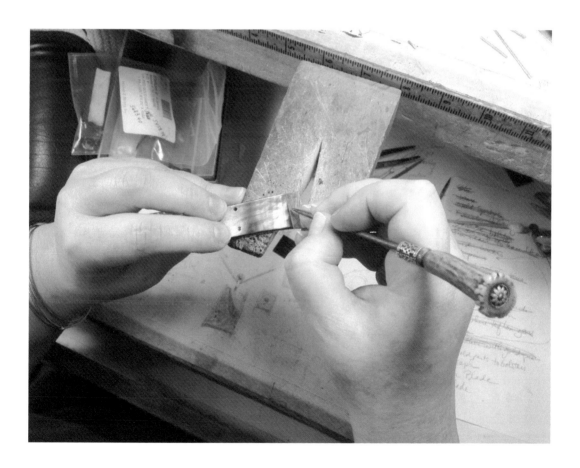

Website:

DellanaDesigns.com

GORDON K. UYEHARA
Honolulu, Hawaii

"Follow your bliss and doors will open where there were no doors before."

– Joseph Campbell

As an artist, I consciously create my pieces— at least for much of the process. To begin, I usually draw a rough sketch to act as a guide. Then, I go about my creation with purposeful intent. There is a point along the way, however, when things are literally out of my hands and uncertainty enters into the picture. Maybe there's a problem with the firing or what looked good on paper looks odd with dimension. Sometimes the unforeseen happens. I am never completely sure when things are going to turn out well. Perhaps that's the way it should be. In my mind's eye I envision the finished product. The actual piece may be more beautiful or interesting than I imagined (transcending the actual process) or it could be a disappointment. That's one of the risks of creating.

Metal clay adds a dimension of excitement. There is a visual and tactile metamorphosis from clay-like to copper, bronze, or silver, from soft to hard, and from organic to metallic. Physical (and metaphysical) transformation is always exciting. It is often said about metal clay, *if you can imagine it, you can build it.* My motivation is to create pieces that are familiar and yet interestingly seductive and to explore the outer design limits of this relatively new art form. I am drawn to natural forms and often express what I see stylistically, and often with a touch of science fiction. I am more excited about what I will create rather than what I have created.

My sister is a professional artist. My father painted as a hobby and after he retired, went back to school and got his masters in sculpture.

I took a few beginning classes and then I spent a lot of time on my own developing my skills. Later I found out that some of those skills were commonly used by others. I also learn from friends and from printed and online media.

26

What is my purpose for making art? Ideas pop into my head and I want to bring them into physical existence so I can share them with other people. It is fun and one of the ways I express myself as a human. Metal clay is the thing I became obsessed with.

Website:

honudream.com

JESSICA V. BURNETT

Northeastern Nevada

"Really clean craftsmanship is so important to me. A great concept loses its charm if a piece makes someone bleed. After that, though, leave space for serendipity and allow for ambiguity. It's taken me a long time to be able to loosen up and do that. The magic happens when that odd little thought leads in a new direction."

– Jessica V. Burnett

Jewelry, like clothing, is an intimate expression of individuality. Like fine fabrics, precious metal chain is an especially tactile form of adornment that conforms to the body and warms to the skin. Chain becomes one with the wearer. A beautiful chain worn alone, or layered with other jewelry pieces, has elegant and timeless appeal.

I personally fabricate and weave my chain jewelry from start to finish using sterling silver, fine silver and 18k yellow gold wire. Hand woven chain is a complex and labor-intensive form of jewelry, and also one of the most classic and enduring.

My mother is artistic, and the medium she often returned to while I was growing up was fiber. I know how to take a raw pile of wool, fresh off a filthy sheep, and turn it into a clean and really badly woven sack. She has a lot more finesse with these things than I did. She dabbled in a lot of things with impressive mastery of technique, but of all of the things she exposed me to, the tactile nature of fiber absolutely stuck with me the most strongly. She told me once that so much of her goes into making something that she finds it hard to part with the end result. Fair enough. I view making as about seventy percent of the delight in experiencing the process, ten percent delight in *I made that!* And twenty percent delight in the delight of the person it goes to live with. To me, art serves no lasting purpose if its existence is relegated to living in a box forever. If I don't find my jewelry a home, that is what its fate will be. In the end, I do get my fascination for making things from start to finish from my mother. She taught me how to teach myself things. Priceless to know.

The only art classes I took in college were the "appreciation" sorts because I didn't believe in my own creative power, but many of my classmates already had me pegged as an artist. I thought I would always be an appreciator, but not a practitioner.

About two years ago, I reconnected with a former college classmate. He looked at my website and told me he always knew I'd end up an artist. This confuses me. HOW DID THEY KNOW WHEN I DIDN'T??? I thought I would be an academic. My professors thought I would be a writer. Neither of those things happened.

In 2001, just weeks after I turned thirty one, I got bad news. I was diagnosed with autoimmune disease in my left eye and was told I could go blind. This remains the most terrifying thing in my life, and maintaining the quality of my vision in that eye continues to be an issue. I realized when I was diagnosed that my independence and ability to enjoy the things I most loved were at risk. I started to take photographs of the places I most love just in case I could no longer go experience them in person. The act of taking the photograph fixed those views and those feelings in my mind against an uncertain future. I had a really crappy camera at the time, but my husband saw that I was developing a new interest and he quietly started upgrading my equipment.

I developed more of an interest in jewelry around 2003—something I've always loved. I realized that maybe I could *make* the things I couldn't buy. It took me a couple of years to figure out my path, but my husband has always been the first person to encourage my interests. He encourages me to mess around with ideas, and he carves out space in our budget and our home so that I can expand my horizons. I may make many of my own personal pieces these days, but the materials and capacity to make ultimately originate from him. I love that—it feels collaborative. He's my most solid supporter without question.

In 2006 I was fortunate to land in two different internet groups at the same time. One was a forum for artists where I met mostly painters and a few sculptors, and the other was an experimental social media site, specifically for artists that had mostly painters and photographers. I still hadn't found my jewelry "people" really, but I think it helped me a great deal to talk to people who worked in mediums different from my own. These people are now among my dearest friends. I think spending so much of my creative discussion time with people who worked differently broadened my ideas of what one "should" be doing. There was discussion about marketing and aesthetics and all of that good stuff, but there was also a lot of discussion about the simple hard work that goes into being artistic. Dedication to craftsmanship, investment in new skills, the importance of developing a style that one can build upon. People who don't spend a serious chunk of their time making, while they love you and want the best for you, can sabotage you without even knowing it. Talking to these people really helped me find my confidence and helped me realize that creativity and the ability to make things doesn't just strike a person like a lightning bolt (mostly), but that it's a skill like anything else—and therefore achievable. It also helped that these are not competitive relationships, but rather very supportive and encouraging relationships. One group would include "non-painting me" by choosing one of my photographs for all of them to use as a starting point for their own projects. What fun! We still do it now and then and have added people into the game who wish to play. There are no rules or prizes or expectations. I own a few of the pieces, but others have been sold, and one was even auctioned for a charity. Perfect. The experience has taught me how true it is that everyone can look at the

same thing and end up interpreting it in completely unique and fascinating ways. That says something about life in the broader sense, I think.

By 2009 most members migrated to Facebook and I followed suit. I also discovered my jewelry heroes there. Much to my surprise and happiness, they are willing to talk to someone who only makes chain! One of the best things about the Facebook experience for me has been the mixing and merging of my art friend groups. It is building new synergies and sparking new ideas for all of us. Sometimes I think people get a little too focused on their own medium when they can benefit from learning about approaches they may not even ever try. Just knowing something is possible is enough to spark off new concepts in one's own work.

I am self-taught. I have always had a love of jewelry. The magpie treasure hunter in me loves the idea of wearing shiny things. I've worn rings and necklaces and bracelets since childhood. Give me a lovely swingy earring and I'm in bliss. In my teens and early twenties, I wore lots of silver and I've always worn jewelry in multiples. Not just one ring—six. A hoop earring as an earring, or repurposed as a finger ring that I wore halfway up my finger. When I met my husband, he started buying me fine jewelry and he continues to add to my collection. It changed the way I saw jewelry in that I felt inadequate when I started making because clearly I can't do *that* yet, but I also started to appreciate that handmade has a completely different appeal. I didn't fully understand that until I started giving work to people. I'd point out the flaws in a sort of embarrassment, and it completely startled me that those little bobbles and imperfections became, for that person, part of what made the piece special. I still have adoration for fine jewelry, and I set high standards for the quality of my own work, but I also now see the value of my hand in the pieces. It makes them unique. Touched by human intention. I like that.

I started making beaded pieces and spent probably two years playing with that before I finally accepted that while I love the beads and each one felt like a tiny piece of treasure, that's not the style of jewelry that I actually am inclined to wear. It was hard for me to design and build with enthusiasm if, in the end, I didn't want to put the piece on and wander around town in it. Most of those pieces were given to others. I do have a love of pearls and gemstones, but I also knew that I didn't have the skill sets to create for myself the style of jewelry I wanted to wear. I was a bit stuck and frustrated and didn't know where to go next.

My husband bought me a chainmail kit, and it was then that I realized that I'm not about traditional jewelry making or gems as much as I'm about chain, specifically. I knew right away. The tactile aspect of chain is pure pleasure for me, plus it also suits my personal style. After the kit experience of assembling pre-cut rings, I went on an internet hunt and spent several months figuring out everything from the math of chainmail to the techniques for cutting metal myself. My husband bought me a jump ringer system after he became annoyed with watching me happily handsaw jump rings for hours on end. I think about how many thousands of rings I've used over the years, and am tremendously grateful he has saved me all of that hand sawing! The precision of how chain goes together appeals to the fiddly aspects

of my personality, but what also appeals is the variety of complex forms that can be achieved from a very simple component: a small piece of wire bent into a closed shape. It doesn't even need to be round. Endless possibilities.

In the process of researching chainmail I discovered Castellani jewelry—which harkens back to Etruscan jewelry—and it sparked off a new fascination. I knew that at some point I wanted to be able to make those tiny detailed woven strap necklaces, but I also knew I had a huge learning curve in front of me to get there. That was intimidating, and I know myself well enough to recognize that I had to take my time in the research phase and then leap in with the willingness to totally destroy things in the process of putting theory into practice. I have struggled with perfectionism my whole life, so that willingness to destroy things phase is often fleeting. I also had a couple of problems to overcome in that I'm geographically isolated and I don't actually enjoy the classroom environment. Going it alone was really my only option. Most of what I've learned has been through research online and from books. Now that I have cyber connections to other jewelry makers, I do ask questions and have been fortunate to get some wonderful guidance via email. It took me a long time to get comfortable with the idea of working with a torch because I found it scary to try on my own. It was a case of having to read about it and read about it, and then just allow myself to be really bad at it for a while (with fire extinguishers at the ready). I still don't like to solder because of all of the chemical steps, and prefer to fuse, but now I generally don't get wrapped around the axle when I mangle things. It is part of the process and it only really concerns me if I'm on a tight deadline for a particular piece or if I'm cutting gold. I plan to acquire the equipment to fabricate my own wire eventually, so even mangling gold won't be quite so harrowing in the future.

I'm currently working towards my goal of making those tiny detailed strap necklaces. I've acquired the necessary skills with a torch and kiln, I've gained an understanding of how to manipulate the metal with hand tools, and I couldn't be happier. It's taken me a lot longer to get here than I expected, but I also learned that pushing myself according to artificial time tables absolutely sucks the joy out of the process of making for me. Ultimately the joy needs to be a factor. Production work is not for me.

I still take out my tiny collection of loose stones, beads and pearls and fondle them, but I'm not sure that I'll necessarily go in the direction of working with them a great deal. A friend recently gifted me with a lovely huge set of opaque enamels that she is no longer using and I am thinking about what I'd like to try with those. Hammering is lots of fun and is a new skill to me (thank you Michael David Sturlin for that push). I didn't expect I'd LOVE it as much as I do. I need to refine those skills as well, but I look forward to that process. I suspect that additional fabrication skills are going to sneak into the mix over time, which is good.

In terms of photography, I seem to have a mental block against teachability. If I can't work it out intuitively and let things just happen, I don't retain what people tell me or what I read about the technical side. I have some really excellent photographer friends who I think have finally given up on breaking my resistance to understanding how my camera *actually* works. They sigh, and tell me when I've

done well, and otherwise let me happily flail along.

It's a very different thing for me to take a photo than it is for me to make a piece of jewelry. Photographs are fundamentally for me. Fixing in my mind a moment— a set of feelings, often. If other people enjoy them, that's great, but it's never been intended to be for other people. I find that people interpret my photos in startling ways, though, and part of that is a matter of geography—of my own mental state, partly—but also of actual geography. I live in an area of large open spaces and people from other types of terrain find it alarming how exposed it makes them feel. To me that space equals freedom of movement and the vastness of time.

I don't think of myself in terms of being an artist. There is too much for me to figure out still to feel comfortable with that title. I'll lay claim to artisan. Craftswoman. Those are comfortable titles.

I think that light and the relationship to emotional space are themes for me that manifest in what I do. Photographs are about light and expansiveness, and jewelry is about light and intimacy. I'm all about shiny metal. The glow of pearls. The light in gems. It's like a set of miracles you get to carry around on your person.

There is a great deal of pleasure for me in knowing that something I've made is a part of another person's daily life, and is not so precious that people—and I tend to think in terms of making for women, although I'm certainly pleased to make pieces for men—feel like they can only enjoy it on a special occasion. Jewelry needs to be worn! I think jewelry should carry meaning—be a bit talismanic, maybe. Every piece of jewelry I own has a reason and an association behind it. It's an intimate and personal code for the events in my life, and I like that. It's a private conversation held in public. People are aware the conversation is going on, but they don't necessarily grasp the content of it. Jewelry can say, "My husband loves me," or, "Screw you, I won't conform!" It can say, "I'm powerfully feminine and will make you weak in the knees." Or, "I carry my god with me." I love the ambiguity and multiplicity of the meaning as much as I love the practical aspects of the materials. I love that people can make jewelry personal and unique by how they choose to wear it.

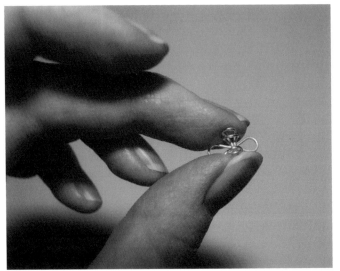

Websites:

Jewelry: jessicavburnett.com

Photography: jvburnett.com

KAZUHIKO ICHIKAWA

Funabashi, Chiba,
Japan

"You might be able to deceive people but you can never deceive material."

— Mr. Inoue (my primary school science teacher)

"There is no 'failure' because you can redo it as many times as you need until you get a good result. Failure just means giving up."

— Mr. Chiyoji Sumie (my jewelry craft school wax carving teacher)

I graduated from the Kyoto Institute of Technology in 1979, where I majored in industrial design. I was interested in the integration of function and beauty. After graduating, I worked for a stationery company as a product designer and a planner for more than twenty years. While I was working as a business person, around 1999, I saw some antique jewelry for the first time in my life. I was fascinated by it very, very much. I started building up a collection of pieces, but then just collecting did not satisfy me anymore. In 2002 I quit the stationary company and entered the Tokyo Jewelry Craft School. I learned the basic skills and techniques of jewelry crafting. Soon after graduating in 2004, I started my career as a jewelry artist.

The first thing I did was make antique-like jewelry with gold and gemstones because this was the reason why I had jumped into this jewelry-making world. My works developed a good reputation and fortunately I won some competitions in Japan. In this period I made my works in many styles; Art Nouveau, Art Deco, and Victorian. One day I found some customers saying that my works had some kind of Japanese mood in spite of their European design. Then I remembered my experience of back packing in my student days. While I was traveling around European countries, I met many people from different countries who had different backgrounds. I just thought that being international meant being westernized at that time. But people I met asked me about Japan, its culture, and Japanese ideas. Obviously they expected me to be Japanese, like a Japanese person. I understood that being Japanese, in other words being myself, is very important to being international.

I started making Japanese style jewelry and am still making it today. But it's a bit different from the traditional Japanese metalwork. I am a jewelry artist. The skills I have are jewelry crafting skills. Actually, I use some Japanese techniques but basically my skills employ western jewelry crafting techniques. It means I have

33

to express a Japanese spirit using western techniques. On the other hand, I still have a strong adoration to European antique jewelry. I think these facts make my works very special. They look somehow Eastern and somehow Western.

My family members have nothing to do with my job, but they encourage me indirectly. I started using Facebook around one and half years ago. I have met many jewelry artists and have seen their works. There are many impressive works that drive me to the next stage mentally.

I learned the basic skills and techniques at a jewelry craft school. And I joined some workshops of Japanese traditional techniques. I think my experience as a product designer in the company also influenced me a lot, especially about my craftsmanship. The company was very, very strict with the quality of the products and services. It was tough work for me to meet its requirements. It demanded deep consideration in details and continuous effort. And I met many excellent artisans of various categories of crafts at this time, from whom I learned how they think and work. But basically I taught myself.

I think the techniques I use are very basic and standard. Some Japanese techniques might look special to you but in fact they are very basic in Japan. There is no special trick in my works.

The point that I always consider is not to hesitate to spend time and labor to make what I want to make.

If someone looks at my work and is moved by it, it should be because of not only the design but also its craftsmanship. This is what I learned from antique jewelry. If you call patience a skill, it is the most important skill for me. And this skill might have been developed in me during my company days. As for design, I learn and soak up the essence from antique jewelry, Japanese traditional metalwork, and other categories of art such as architecture, interior design, sculpture, ceramic art, fashion, etc. The Japanese sword, its decoration, and Obidome (a Kimono belt ornament), especially, are my favorite influences now. Every time I look at them, I am moved by the beautiful design and precise craftsmanship of unknown craftsmen in old days. You may find their influence in my design.

The question "why do I make art?" reminds me of a story of a frog and a scorpion. The story goes like this:

A scorpion is on the riverside. He wants to go across the river but he can't swim. He meets a frog. He asks the frog to put him on his back and swim across the river. The frog refuses it because he thinks the scorpion will sting him. The scorpion says he won't because he knows if he stings and kills the frog, he will drown. The frog thinks it's a rational idea and starts swimming with a scorpion on his back. But in the middle of the river the scorpion stings the frog. The frog asks why he stings although he knows he will die. The scorpion answers, "Because I'm a scorpion. It's my nature to sting someone. I can't help it!"

Why do I make art? I make art because I am an artist. It's my nature to express my passion. I can't help it although I know it's tough to make a living by it. Of course I could have chosen paint, sculpture, music, or anything to express. The reason I chose jewelry might be the fact that I was set on fire by antique jewelry. If I hadn't met antique jewelry, I would have never been a jewelry artist. I guess it sounds like I look at myself as a fine artist but because of the background as a product designer, I know jewelry only can exist with fashion or the life style of the person who wears it. It's important to think about the coordination with fashion and occasions when you design jewelry. I always want to make a woman look beautiful and make her a center of people's attention. I made jewelry of gold and gems mainly because the antique jewelry that I am fascinated with is made of them, but now I'm making jewelry of silver, copper, and other Japanese alloys. And I often use a Japanese patina technique called Iroage. The combination of these metals and techniques gives a very beautiful and unique expression to the piece and you who will wear it.

Websites:

etsy.com/shop/KAZism

facebook.com/kazism.jewelry

farlang.com/profiles/kaz

facebook.com/kazuhiko.ichikawa1

www006.upp.so-net.ne.jp/p_compose/

BORISLAV RANGELOV Plovdiv, Bulgaria

"Live your life in freedom and create yourself!"
— Marcus Aurelius, the Emperor Stoic

"All my life I have been down this road."
— Borislav Rangelov

My artist's statement and my faith are found in these simple words by my wood carving teacher Emil Ferdinandov, "The things that do not happen are the things that are not being focused on." The fact that gems are very difficult to engrave upon and that since antiquity there have been very few people who have dared to try it, is exactly what makes me enthusiastic about having gems as working material. For many years my work consisted of wood carving, which constituted a very good ground for the subsequent development of my gem engraving skills. I have been entirely devoted to the latter activity for eleven years now. Engraving gems takes precision and is extremely challenging; that might be the reason why I feel so incredibly satisfied facing the end result. I worship my job!

None of my predecessors have ever had anything to do with art. I have been painting since I was a child and I have always considered the time spent in painting or sculpting the most pleasant and meaningful activity.

Wood carving gave me the chance to follow the steps of one of the most talented Bulgarian wood carvers, Emil Ferdinandov. My willingness to learn along with his teachings and direction proved to be a good combination and helped me grow as a wood carver.

As for my gem-engraving skills, I have not been under anyone's direction. Sixteen years ago I saw, for the first time, a Roman intaglio representing Adina Palada's figure, engraved upon carnelian. I was stunned by the fact that so much beauty and detailed punctuality could actually fit on such a tiny surface. Ever since that day I have been looking for methods used to engrave on gems (material which is known to be extremely hard to work with). After five years of searching, attempting, and several trial and error sessions, I finally found the technology used



by the antique craft workers. This antique technology still outweighs our modern technologies and tools.

What is my drive or motivation for making art? My answer to that question is very succinct—art gives me freedom and flight of the soul.

Website:

cristalgemart.hit.bg/

SERGIO FIGAR

Gorizia, Italy

OMNIA VINCIT AMOR

To apply the idea of a jewel to the surrounding environment, to objects and to people was, and still is, a fine play, a nice travelling mate: sometimes it's ironic and visionary; sometimes it's the guardian of old traditions. The synergy that is being created between shape and color is the real glittering that these jewels bring along with them as a dowry. Passion is not enough. Love is needed primarily so as to make dreams come true without risking that its halo would be lost. My specialty has been the "Commesso Mediceo" or "Commesso Fiorentino" (Florentine mosaic of hard stones). For more than twenty years, my work has been made of stones matched with contemporary jewels. The pastel nuances of lapis lazuli, jaspers, and aventurines, make up the chromatic structure of the jewel whereas the opal, with its magic, opens a window; an eye into the inner self of the artwork.

My childhood is permeated by the stimuli or, instead, the stimulus itself — events of everyday life. I was trained to care and to reason.

All the experience coming from my parents' jobs made it easier for me to be willing to perceive events and to transform them into creative stimuli.

There were two mainstays of my childhood upbringing. First, my father's scientific passion for mycology gave us the opportunity to experience loads of adventures pertaining to the almightiness of nature. Second, was the deep love my mother had for the history of art of the whole world and especially the Far East.

My father worked as a chemical technician, and his great passion was mushrooms: he picked them up, catalogued them and analyzed them through the microscope. He shared and passed on to us all this macrocosm and microcosm that we were all immersed in.

My mother, who was a teacher of technical education at junior schools, taught us to watch the shape of objects, their details and above all she taught us how to make things with our hands. Just like her students, we created small items with her such as a leather pouch—our casket of hidden treasures—or we re-bound a booklet with a copper layer that, as if by magic, became a precious gallery of drawings and notes always to be kept with us. Therefore we, as kids, had always been aware of the fact that it was easier to destroy things rather than make them; actually we picked up a certain practice in the field of demolitions too! However, being able to make something manually also meant being able to fix it again, make it new again and even more beautiful than before. This interest in "making things" grew up with us, and became a very important aspect, even an existential one, of our dealing with other people and it is still as such today.

I have always been attracted to colored shapes. The color matched with shape could not be parted from me and, therefore, it has always been spontaneous for me to drive my aesthetic research towards it. Early on, when I attended junior school, I had my first experiences with cold enamels on copper shapes. Later on, when attending my five-year high school, I specialized in goldsmith education by choosing to attend the Goldsmith Section at the School of Art. I began making experiments with fire enamels, the oxidations with salts and different goldsmith techniques to obtain newer and newer effects upon the surface of jewels. This universe of shapes, surfaces, and colors stimulated me more and more and drove me to keep on making what was not only an experimentation of technique but also research for the architecture of light. The same happened with plastic shapes and so the quick sketching of pencil on paper, to develop a technical detail of the construction of an object, became a continuous practice, even a morbid one. Nowadays, the immediate drawing remains a key point of my "making goldsmith items," of my being a goldsmith.

I was struck by true love in Venice when, after having sat for my final examination at the School of Art and Trade at the Faculty of Sculptures of the Accademia di Belle Arti, I strolled and snooped around this magical floating city. Venice! Full of Far East and of colors reflecting on water. I popped into, as if by mistake, a cozy goldsmith atelier. The tiny shop window soon caught my attention and, as soon as I put my face close to it, I was literally sucked up by a whirlpool of colors, shapes and glittering. Those jewels inebriated my mind while my body remained rigid like a statue with my nose stuck against the glass. The jewels were unusual and I had never seen anything like that before. *Here are my jewels!* I thought. They had everything I was fascinated by and, above all they had the opal with its magic.

All the artwork I had assimilated from the picture galleries I visited with my mother, all of the marvelous adventures of my Arabian Nights imagination, were sparkling there. The atmosphere of Venice was embedded in those jewels, with its Byzantine mosaics all made of golden layers, its domes, which were symbols of the universe itself, and the seawater. The seawater became the architectural structure of a city and, at the same time, mirrored the light of day and night, changing its look all the time.

In a second, I realized that indeed I was living inside the dimension of the jewel I had been longing for so much. All of a sudden the experiences I had with my father, while looking under the microscope, came up in my mind; watching the mushroom spores, or lichen and, as if in a play, I found again in those images the silhouette of a mountain or the profile of the tree under which we had found that specific mushroom. In those images I recognized the nature where we had lived so many experiences and shared so many joys. In front of me, however, that shop window was still there: the farthest checkpoints of an atelier, just like the fingers of a hand, are for the body though I was interested in the soul.

I had to meet the maker of those marvelous jewels: my master. Learning the skill of the *Commesso Mediceo* of hard stones became for me like the need of breathing or eating, a vital necessity, which came before everything else. I had to learn quickly and what I felt was my expressive way and also, my spiritual direction.

Actually, as time and years went by, the object—jewel— metabolized and, what I found in my inner self was no longer just the surface of a colored shape or the eclecticism of an old technique. By far the jewel had become consciousness of a vision that was shining inside me and was radiating from my heart up to my mind and continued further down to the body, to the hands. Love is the real jewel and it is indeed from this jewel that inspiration is born. The idea, the drawing and eventually the material shape; the object. If this object is really the 'fruit of love,' then it becomes a work of art and it keeps within itself a sparkling of that light which enlivens everything and becomes a transmitter of joy, a real entity which every day comes in touch with the surrounding world and keeps on telling this story just like I am doing right now.

A careful man contemplates the joy of nature and thus he participates, one more time, in childish astonishment that so much marvel brings with it, as a gift. Such a joy, which has been sung in a jewel or a ring throughout the years, like a colorful star embellishing the neck or the hand, is the tradition with which the inspired goldsmiths continue to follow, so that when the word "jewel" is pronounced, everything suddenly brightens up and fabulous treasures come up to our minds again, as if by magic.

Aesthetic nomadism along with contamination of styles have contributed to pull down those barriers made up of stereotypes which marginalized the jewel to the boundaries of the so-called minor arts; so much that today, at last, one has the opportunity to "wear a picture or a sculpture" and to be able to share such a "joy" with all the world surrounding us every day. That's what a real designer jewel is nowadays: a transmitter of joy!

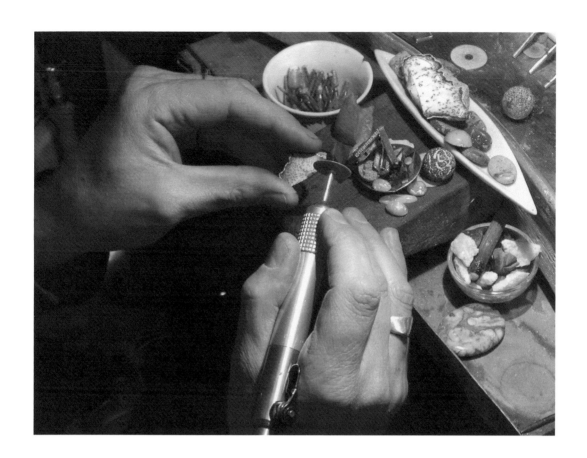

Website:

antracite.it

Sophia Georgiopoulou

Seattle, Washington
(formerly from Athens, Greece)

"My philosophy is very simple: a goldsmith needs skilled hands, in-depth knowledge of the material and the tools with which he works and a profound understanding of the millennia long tradition of jewelry making."

– Sophia Georgiopoulou

The name of my studio, Kosmimata, derives from the ancient Greek word "kosmos," meaning universe, world, order, harmony, decorum, ornament, jewel. The word "kosmimata" connotes adornments, appropriate to the natural order of the "kosmos," jewels and ornaments. My studio *was so named* because I am always inspired by the amazing jewels produced by the splendid civilizations that flourished around the Mediterranean basin in ancient times. The way the craftsmen of old achieved such a degree of perfection in their pieces using only a few simple tools, metal, and fire, always poses a challenge to me as a goldsmith.

My designs are primarily inspired by the Roman, Hellenistic, and Byzantine past of the Near East, adapted to a more modern aesthetic. Since my classicist education has always drawn me to the ornate, intricately wrought gold jewelry that prevailed for centuries in the Mediterranean basin and the Near East, my work focuses on a reinterpretation of these timeless forms. My work seeks to create a bridge between the beauty of the ancient cultural heritage in this area of the world and modern life.

In my work I try to combine the traditional jewelry making techniques with innovative design. I am interested in building a body of work that will be relevant to the present time but also represent, in terms of techniques and skill, a link to the jewelry making traditions of the past.

Excerpt from my book *Kosmimata: The Art of Goldsmithing:*

"My first recollection of the beauty and sound of jewelry is associated with hazy, summer afternoons at the house of my grandmother. After work, she would sometimes sit in her bedroom with the windows open

to the breeze, take her jewelry box out and reminisce about each piece and its journey through time. Although I was attracted by the tinkling and lightness of the gold and the sparkle of the stones, the family pieces fascinated me because they were a live record of the history of my mother's family. They spoke of the sea and of merchants ships, of long and dangerous journeys, of betrothals and marriages, of happiness and disasters, of wars and losses; they were the witnesses of the family's existence during the turbulent centuries of the Greek Diaspora in the Ottoman Empire, Russia and Egypt; they were the family's saviors in Attaleia in 1856, in Alexandria in 1904 and in Odessa in 1917."

So it seemed to me that the jewels I often held in their velvet box were more than a happy convergence of design and metal. They were invested with a quality that succeeded in transcending time, a quality that for many years, as I was growing up, I tried to define and isolate. In my mind, they were primarily manifestations of beauty, love, faith, wealth, history and almost never superb achievements of craftsmanship performed by the human hand.

With time, since I was the only girl in the family, I was given the remaining pieces of jewelry, even those that were extremely fragile and beyond repair. I loved and cherished them as historical pieces, took care of them but still did not wonder how, or by whom, they were made. At university, I chose to listen to my love of history and the classics and ignore my advisors who recommended I apply to art school. Ironically, it is my studies of the classics and Byzantium that finally led me to understand the quality possessed by the jewels in my grandmother's box. The elaborate, enameled initials of Byzantine manuscripts, the fastidious lines of the scribe on the parchment, the ornate stone carvings of the pediments of the temples and churches in Asia Minor, the golden tesserae of the Ravenna mosaics, all spoke to me of the hand of the master craftsman and maker. Thus, the need to earn a membership to this select society of master craftsmen became overwhelming and made me realize that I, above all, wanted to make things, rather than talk about them.

Granulation Technique

Of all the techniques studied in my metals classes (with my teacher, Dimitris Nikolaidis), granulation attracted me most because of its tremendous potential. The granules gave roundness to surfaces, even to the flat ones, they reflected the light when polished and they rendered unparalleled richness to each piece without the addition of stones.

On the down side, learning the technique itself was an uphill battle. Flat surfaces presented no problem, but flat surfaces did not appeal to me. I wanted the granulation patterns on curved, concave or convex shapes to give them volume, texture and a certain "voice."

The "voice" of my pieces was very important to me. I wanted them to be

recognizable as my work, but to simultaneously refer to their historical antecedents in times when goldsmithing was just the application of the skilled hand and of fire to the metal. By choosing granulation as the main vehicle of giving form to the metal (gold, silver), I wanted to create shapes in which the metal is sovereign. I wished to form the metal by using techniques that were determined by the very properties of the metal (its ability to fuse) and not submerge the metal into a sea of gemstones. In way of my thinking, the granulation studding of the metal was the equivalent of the gemstones, but only better because it was of the *metal* itself.

Art

During my years as a college professor, I kept searching for ways to balance a full teaching schedule and a family with being a full-time art student. It was an impossible task that I gave up on quickly. In 2004, I decided that if I truly wanted to become a goldsmith, I had to give up teaching and devote myself to learning metalsmithing from scratch. The six years of apprenticeship that followed were years of effort, patience, setbacks, difficulties, and insecurity, but also years of fulfillment. The ideas I carried in my head for the longest time materialized into concrete pieces of jewelry.

I create art because I love beautiful things that transcend time. I believe that the skilled human hand has the ability to confer timeless beauty onto many a substance around us. Jewelry making is but one of these instances of conferring "the artifice of eternity" onto formless matter. Designing a piece and watching it grow out of the metal is almost an epiphany, a revelation. The piece then acquires an autonomous entity, a life of its own, and takes its place among similar pieces that constitute its link with the jewelry making traditions in the course of time.

Knowing and respecting the properties of the metal I am working with is one of my primary concerns. "Listening" to what the piece is trying to tell me as it comes into being is extremely important. Occasionally, I have to make drastic changes to the original design because, carried away by the enthusiasm of my initial idea, I have ascribed elements to the piece that are foreign to the nature of the metal.

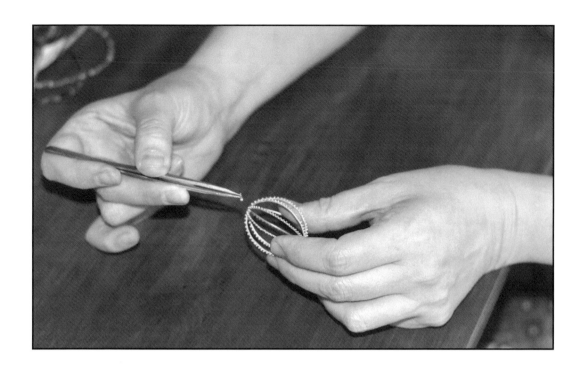

Website:

kosmimata.com

STAN BISSCHOFF

Gulpen, the Netherlands

"Handmade is not an excuse............it's a privilege!!!!"

– Stan Bisschoff

I am a goldsmith who is very interested in shapes and lines. My inspiration comes from investigating ways of looking at things. Forms from nature can lead to a design. Also, elements in architecture can lead to design; a beautiful compound or structure can set the designing in motion. The train station, La Gare de Liège-Guillemins,—absolutely fabulous!!! Inspiration is all around us and I love to take pictures of it!

I grew up in a Catholic family with two older brothers. We lived in the south of the Netherlands, in a small village called Simpelveld. At the age of seven I discovered the fun of using my hands for creating. I started to glue pictures on wooden panels and then cut them with a saw. I also started to make drawings.

Several years later I met a local artist. He was a painter of fantasy drawings and a photographer. From him, my love of drawing and photography was stimulated. Nature also received much of his attention and together we discovered the beautiful secrets of nature surrounding us. This artist, Jan This, laid the foundation for my creativity. This is something that I discovered while writing this story, strangely enough.

When I was twelve or thirteen years old, I watched a documentary on German television about a goldsmith. That was when I decided what I wanted to be. This was the right combination of creating something with my hands and mind, and my constant urge to be somebody different and do something that others don't do. My mother understood my drive, and she encouraged my decision.

I had a very close relationship with my mother. We only needed half of a word to understand each other, and we both seemed to understand that there was

46

more between heaven and earth than you could see, or that the church wanted us to believe. Somehow we were both more spiritual than we ever really understood, as long as she lived.

At the age of sixteen I went to Schoonhoven, where the only training for learning to be a technical goldsmith in the Netherlands is located. This school was two hundred kilometers away from Simpelveld, so I was forced to be independent at a very young age. From Monday through Friday I was in Schoonhoven. On the weekends I would go out with my two older brothers and a large group of friends. I also spent much time with my mother. During this time I met my first wife.

I graduated and started to work at a jewelry shop where I did only the repairs. In the years that followed I got married and started a new life in Eys, a small village located three kilometers from Simpelveld.

One day I discovered a small shop in Gulpen, five kilometers from Eys, which was for rent. This was the very beginning of a dream, starting my own jewelry repair shop. But it was only a dream and due to circumstances at that time, it was not encouraged. So life just moved on, but the dream was still there.

At the age of twenty six my life suddenly got messed up. My oldest brother, Paul, died of sudden cardiac arrest. He was only thirty two years old at that time. From that day forward, I realized that it was pointless to make plans for your life. I started to look at life from day to day. The bond with my mother grew even stronger. The five years that followed were years of many negative things, except the birth of my oldest son, Yannick. My mother got cancer and died at the age of fifty nine after three years of suffering, I was thirty one at that point. Again, life just moved on. My second son Yaëll was born, and while this was a very good thing, I missed my mother very much.

I changed employers three times and ended up working at the casino. Still there was that dream, and the dissatisfaction of how my life was going so far grew. I started a small repair atelier in one of the bedrooms in my house and started to repair for three jewelers. Every now and then I made a piece of jewelry designed by myself, but mainly I did repair jobs. I continued working at the casino.

At the age of forty two I had had enough of the way my life was going. That dream I had became more important. The little shop I saw almost twenty years ago became available. I decided to finally live my dream instead of just dreaming. I quit my job at the casino.

The twenty-fifth of October, 2007, Ateljé Esbé, the phonetic spelling of atelier and my initials, opened their doors for business. This was the first day of the rest of my new life. I started this shop as a repair shop and sold some new jewelry from fellow goldsmiths I had met in the past. I never had the confidence that I could create new jewelry of my own designs. But people started to ask for special goods made by me, so I started to see myself from a whole new point of view. In the past

people wanted me to act within the context of the village, and now the clients came to me to deliver something different and totally out of the box.

Again my life took a different turn. My marriage bled to death and I met my new girlfriend, Marie-José, who is a goldsmith also. We share the same passions like photography, and creativity is stimulated more. We constantly trigger each other and also learn from each other. Marie-José is much more creative in form then I am, but I approach the making of jewelry in a much more technical manner due to my repairing background. But the biggest win for us is that we stimulate each other to look differently at our environment and, in turn, the jewelry we make. We visited Rome this year, for instance, and all the tourists were taking pictures of the Colosseum. We, on the other hand, were taking pictures of the fence on the other side. We saw the beautiful combination of lines in that fence. The tourists were laughing at us but we had the most fun!!!

Because of her I have found the confidence to make jewelry the way I make it now and she gave rebirth to the foundation that Jan This laid almost forty years ago.

I'm also aware of the important role my mother has played in my life and the role she still plays now. Somehow I have the feeling that she is my guide. These feelings are things Marie-José and I share too.

My first goal was not to make art but to pursue my interest in goldsmithing. My interest was based on working with metal and a flame. Using traditional techniques was my main reason to choose this beautiful craft. Now I know that I'm able to make art in my own way. I'm able to control the metal just the way I want to. Most of my designs are based on contradictions. Like round versus square or rough and matted versus flat and polished. I guess this is based on the changes that life had in mind for me. One moment everything is all right and the other moment the telephone rings and somebody tells me a terrible message.

Nowadays people seek me out because of the way I exercise the profession of goldsmith. I had started to find a way to express my technical skills on a creative level. I look at my current jewelry as a technical creative expression of design. Because of this expression more and more people, including artists, find their way to my atelier. And I get in contact with more and more creative artists.

The two most important things in my designs are that they should be wearable and close to perfection. I will never make a concession in those matters. I'm sure that many artists, goldsmiths in particular, use "handmade" as an excuse to deliver something that is not perfect. My goal is to make jewelry that is close to perfection. When you look at it that way then it's a privilege that I can make something by hand.

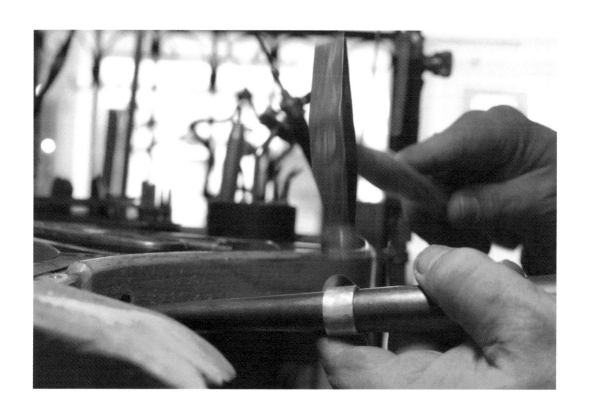

Website:

atelje-esbe.nl

WILLIAM C. WEBB

Columbia, Missouri

"Art. It is sort of a personal thing. It's something one does in private, using our own private warehouse of capabilities. It is then shared. Art is where this master stuff is exercised, honed, accomplished. If you are going to do it, do it well."

– William C. Webb

Art is one percent inspiration and the rest hard work. Art is not a noun in my understanding. My work, my silverwork, is an attempt to make something meaningful from a position of little advantage; I have little to no money. My work uses more primitive methods resulting in simpler products. I attempt to make a product that is right in silver content, right in stonework, soldered clean, sanded, buffed, and ready to wear. My pendants hang right, my earrings dangle well and correct, and my rings are solid and feel good on. Simplicity is the key for me, and perfection of work practices are of most importance.

I am a self-motivated, self-starter. My father, bless his soul, was a military man. No room for kids, no room for art. My mother was uneducated, not talented but smart. She was not encouraging to me. "Get a job" is all she knew to say. "You can't make a living from doing artwork."

Stacy, a Navajo rock carver, gave me a milk jug full of turquoise pieces, along with twelve five-gallon buckets full of scrap cutoffs from a job just completed. I was in heaven. I then bought about three hundred dollars worth of tools and silver from Indian Jewelry Supply in Albuquerque, New Mexico.

My mother developed dementia. I came home and cared for her. In her basement, I cut and ground rock and sanded, buffed, and polished so many cabochons and arrowheads. I got my lessons, bloody fingers and all. I'd work sixteen hours a day and sometimes stay up days on end. I had little or no money, but at the end I had about forty thousand dollars of good turquoise cabs. I had 1400 cabs of other stock and shell and arrowheads that I had carved. The hard work I had done was my inheritance, and I had my future.

I read the book *Indian Jewelry Making* by Oscar T. Branson. It is the Bible among the tribes for the beginner. It is explicit and is a good instruction manual. I had some over-the-shoulder glimpses of Ivan Howard, a fine silversmith. While he was working, he taught me four lessons:

Wrap a bezel and solder it.

Solder bezel to plate and file it.

Solder the pendant bale to the plate.

Insert the stone.

He also taught me how to use the buffing wheels. From that point I spent three years in my mother's basement working. I spent time teaching myself and working on perfection of assemblage.

I make art because I can. If I couldn't, I wouldn't make it. I was a draftsman, a painter, a painter of signs. I am a lettering specialist extraordinaire with flair. I am familiar with the processes of most crafts, e.g. stained glass, clay, and weaving— hands-on stuff. We invent ourselves. We work at becoming who we want to be. Sometimes the image is clear, and sometimes it is given to us, wrapped like a gift.

I have made something of that little boy, that little boy who kicked a can down a dirt country road. I haven't achieved bulging bank accounts or happiness with family, but I have made beautiful things. I have achieved value as a creative being. From this world I have made an offering back to the spirit from whence I came. I am pleased with the outcome of my efforts. I am able to say about myself: "A life well spent."

Website:

etsy.com/shop/
SterlingSilversmith

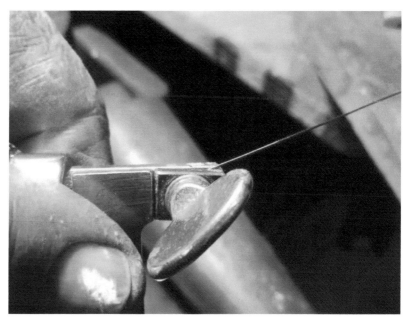

CPSIA information can be obtained
at www.ICGtesting.com
Printed in the USA
LVIW022123200512

282531LV00002B